The Yellow Petal

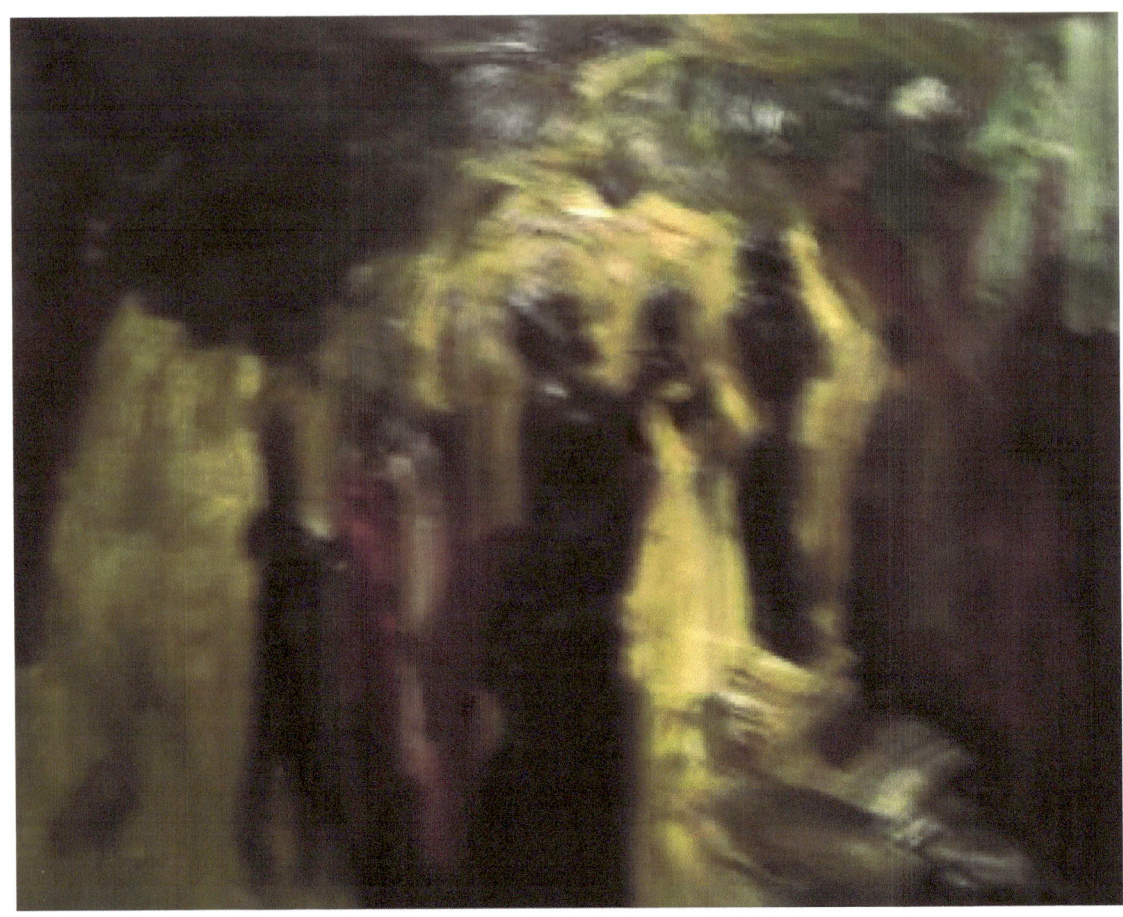

'Temptation'

This is a book written as the real sequel to Blue Horizon.

Yellow Fury

The sun the sun,
Van Gogh it burns your mind,
Make hay, make hay,
Or else spend old age,
Honest.

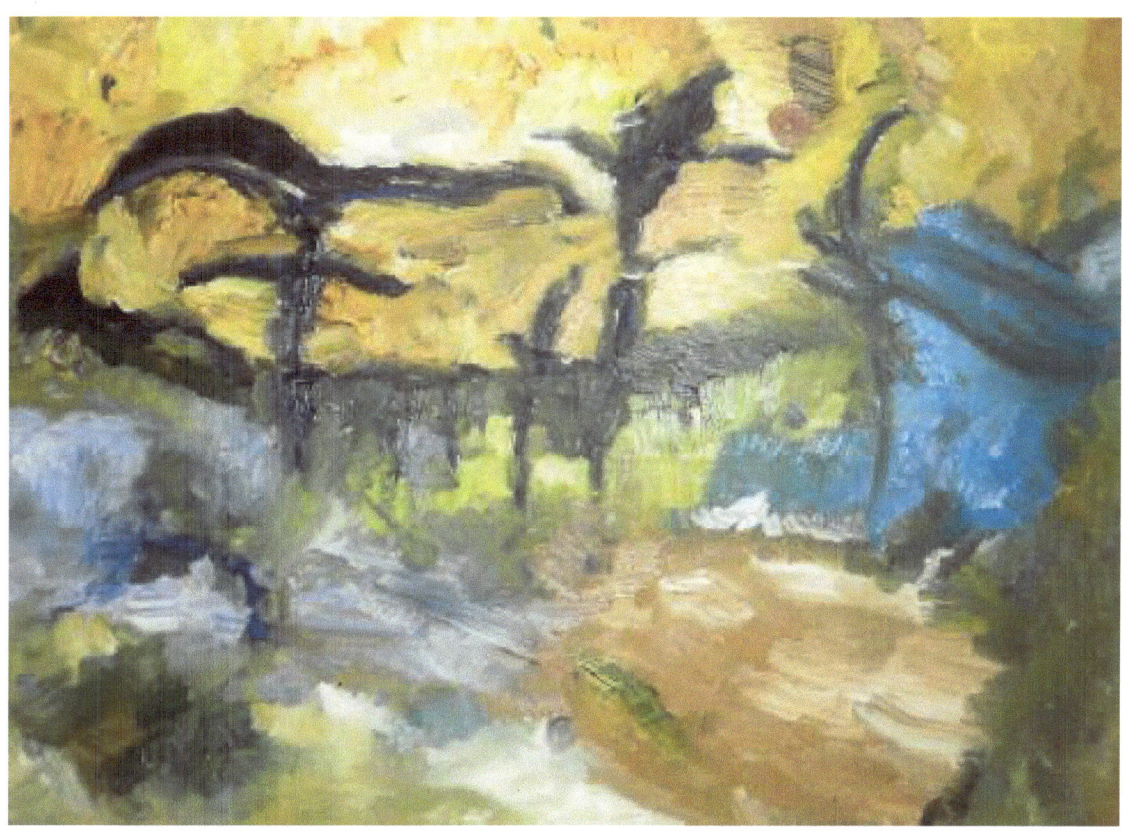

'The French Riviera'

The Big Issue seller

As I watched him,
Sell his wares,
I counted my coins,
Only to find I was short.

He immediately saw,
Came over,
Gave me some 20 pence pieces,
And then he said,
'I have lived every second of your eternal life.'

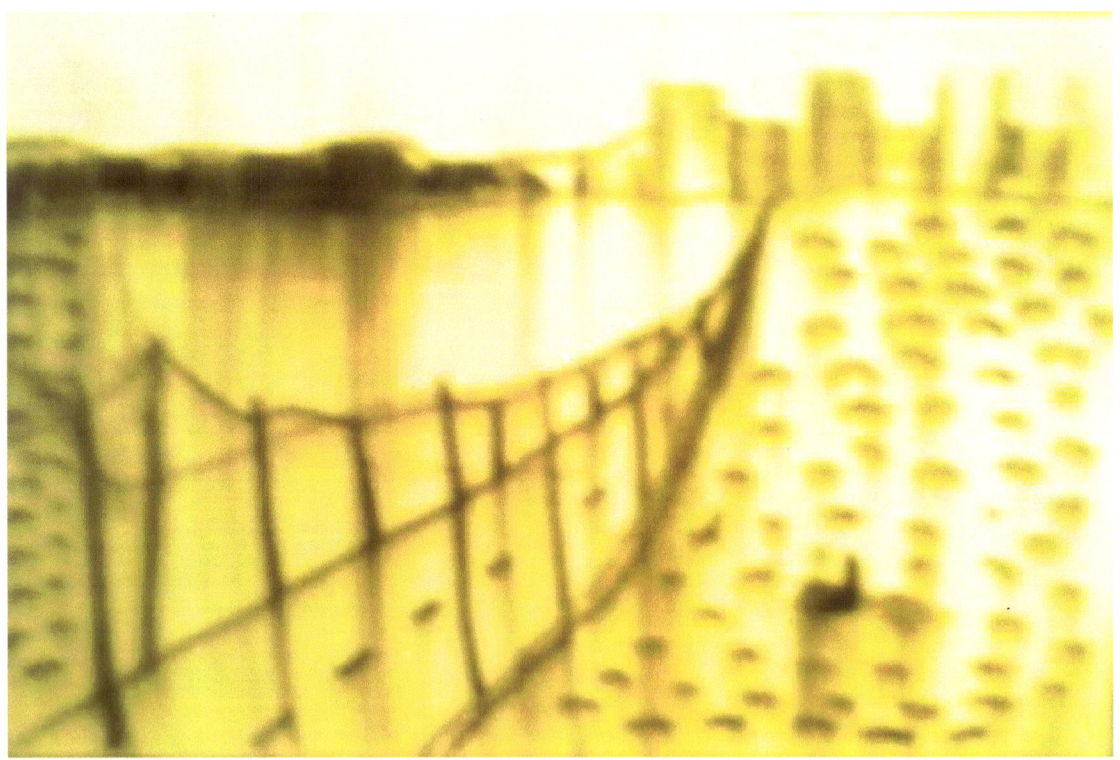

'The bridge between worlds'

The Grounds

Walking round the grounds
Of the graffiti artists mansion,
I noticed the years turning,
Me yellow blue.

In my haste I said,
'Have the seasons started'
'No they said,
'They've been destroyed.

'Oh my heart!'

Shiva's damned world

No good, no good,
The crows cry,
He gave Kali a fist f***,
No luck,
Killed a couple,
And said it was the Devil,
The ear of corn did hear,
The world is an asylum,
Here's to his redemption.

Kadmium Star

3 WALLS,TWOCEILINGS,
The proximity,
Insatiable,
Behind the sun,
Paradise,
Why does it hurt?
Death of the kamikasze,
Society red,
Stakker humanoid,
Summers child,
Wild.

How to make a vurt feather

Sideways squint,
Paintbrush aloof,
Mind uncaught,
Not too much pot.

Paintbrush of hair,
Pubic or not,
Blank books of no worth,
Finger middle,
Outward journey,
Not too much imagination.

Finally name the bar******
You don't get paid,
People take a holiday from reality,
And you suffer insanity.

4 Steel souls

These need to be caught,
Nazi nastiness only prolong pain,
Where is a room of four computers,
Four people who speak German,
And who never sleep.

Nazi conspiracy

Between waking and sleeping,
I noticed two men,
I knew they were Nazis,
They were measuring my body
And what's more they had a name for my body shape,
Geradeaus,
They called it.
Further investigation proved there is a paedophilic cult,
A subdivision of the Nazis,
Who rule this world by stealth.
All the media is theirs.

To find a daughter lost

Lena lost,
I keep crying out ''where is my daughter,where is my daughter'
'She is in heaven, 'they all say,
How do I get there?'I say
No hope in hell
I know she is in the vurt,
Not heaven,
I seek curious yellow,
Can anyone help?

The nature of the apocalypse

One day a vision of total destruction,
The next richness and warmth,
I sit on the hill,
And look to the future,
Every morn,
It changeth daily,
Contrast so vast,
It rips you apart.

Art versus paedophilia in the 21st century

It used to be cogniscenti versus intelligentsia.
Now the battle has taken on new forms,
Art is infinite he says,
'Haven't you ever known a person,' she says
'You can only know a person through their art' he says
'You're a good f***'she says
Which will win,
Its been going on forever,'
Someone interjects,
He walks away
'Sigh'

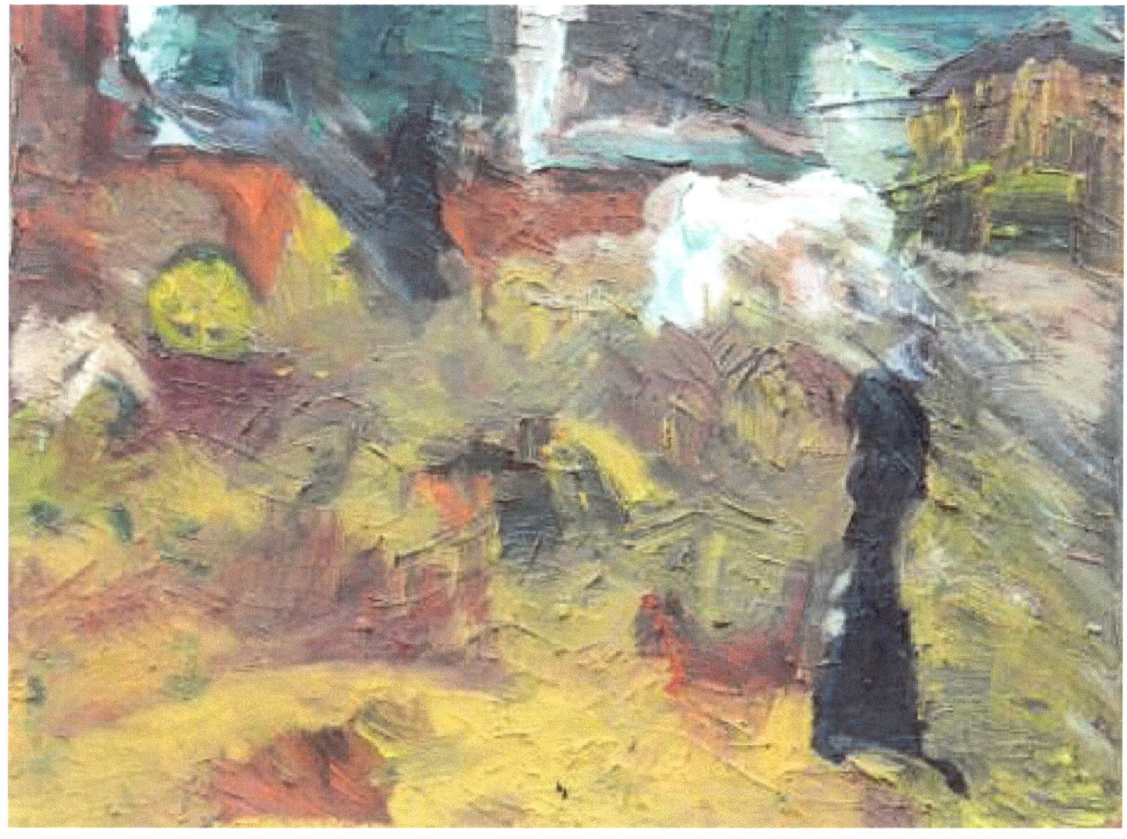

Mothers are the necessity of invention

One morning quite early,
I knocked on the door of my mothers room
No answer so I burst in,
Man, she was cross,
-She was dressing,
So the next week,
I ordered a big mdf board from the DIY store,
Painted it in the Japanese Master tradition,
The paint dried,
Then I cut it into three equal parts,
Today I put hinges on,
And finally presented my mother with a
Japanesescreen.

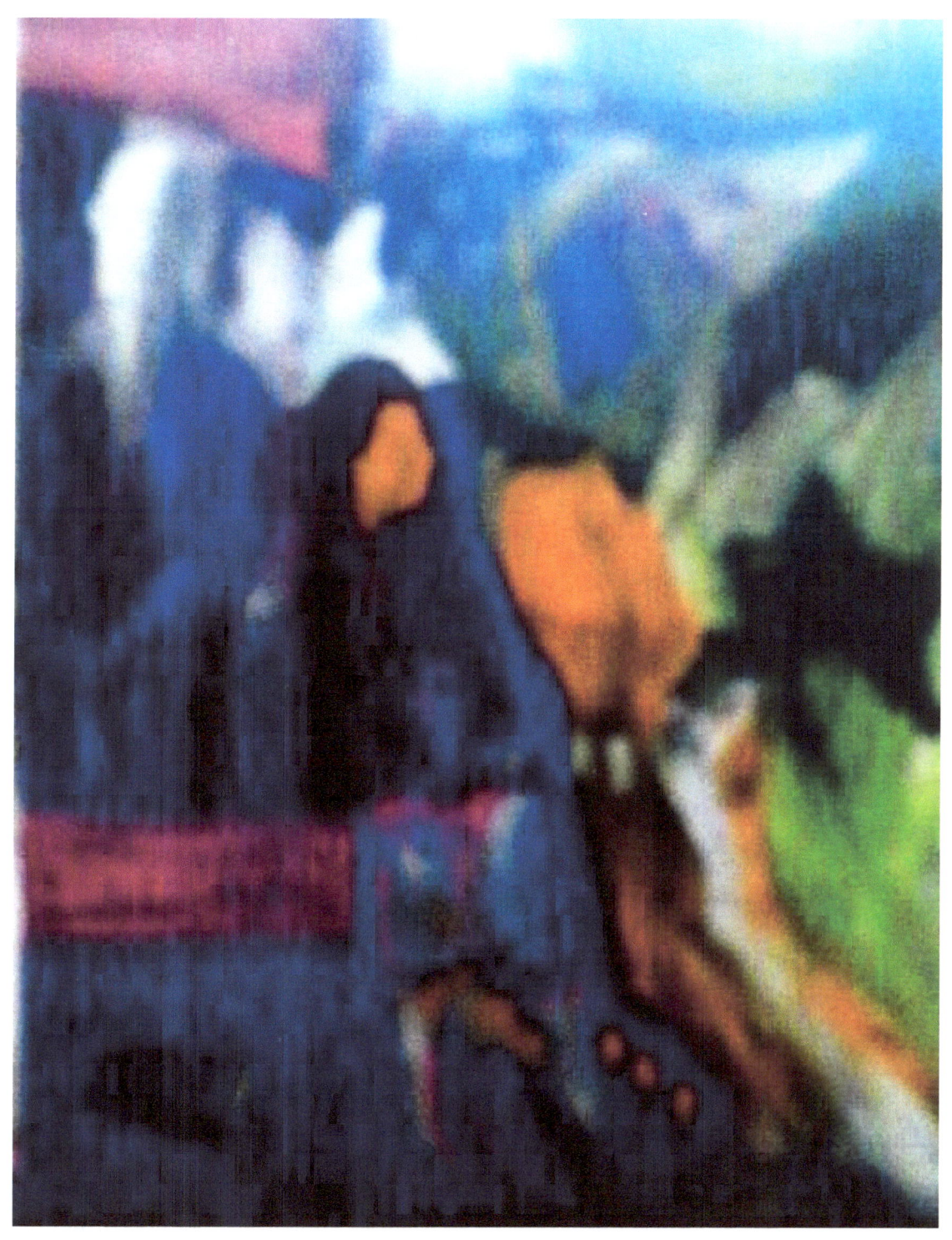

Christmas shopping.

To the superstores I went,
Three towns in three hours,
Many faces old and young,
Dull towns with dull buildings,,
And yet as I walked among them I could feel their love.

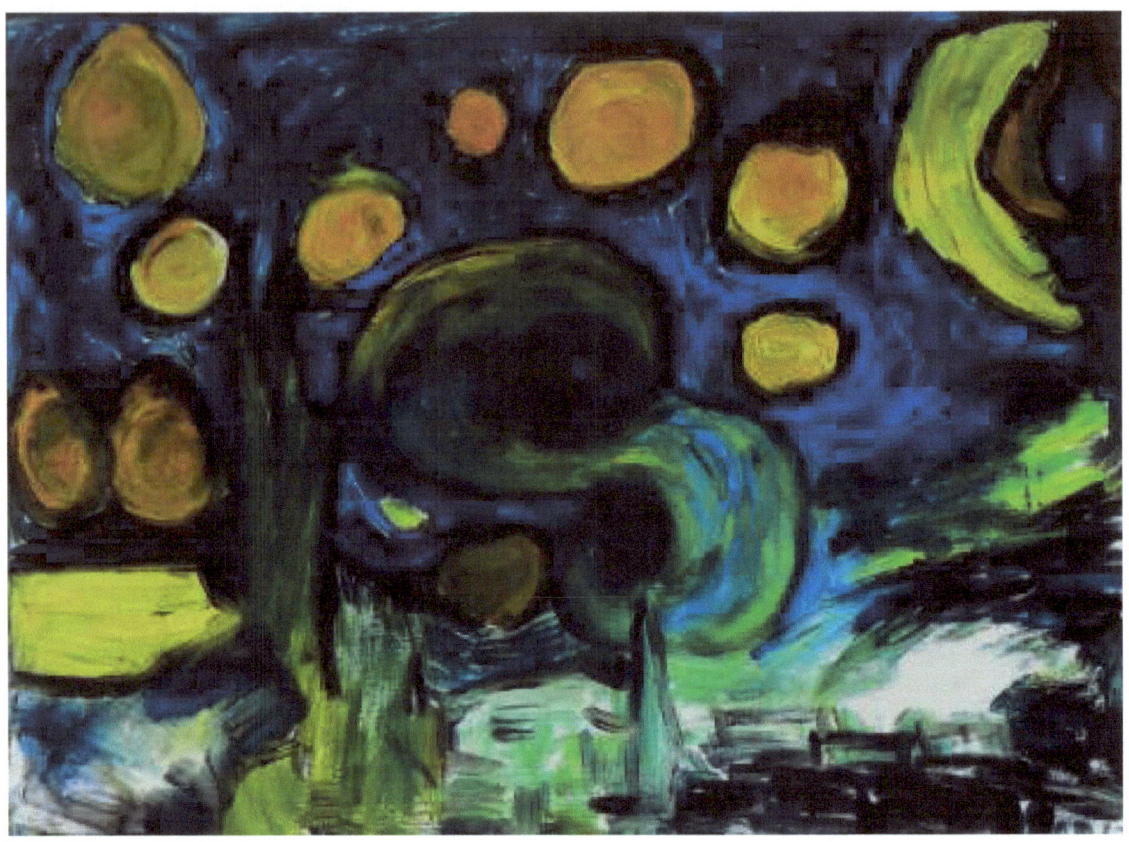

Tangental Ben

Whenever I keep going off at a tangent,
There he is saying,
Means nothing friend,
And points to a blank
canvas.

Revolution of thinking

We are the parasites on the earth,
We are bandying words with our Creator,
Babylon is burning blue,
And the people are getting scared of you,

England will be drowned by tears,
Who wants to live another year,
Christmas is over, a misonomer,
Survival on the shore.

The wreckage of carriageways,
Jacknifed and strewn,
Every voice speaks of doom,
From night to noon.

The rich are begging in doorways,
The homeless have taken back what is yours,
The underground know the score,
All we ever wanted is more.

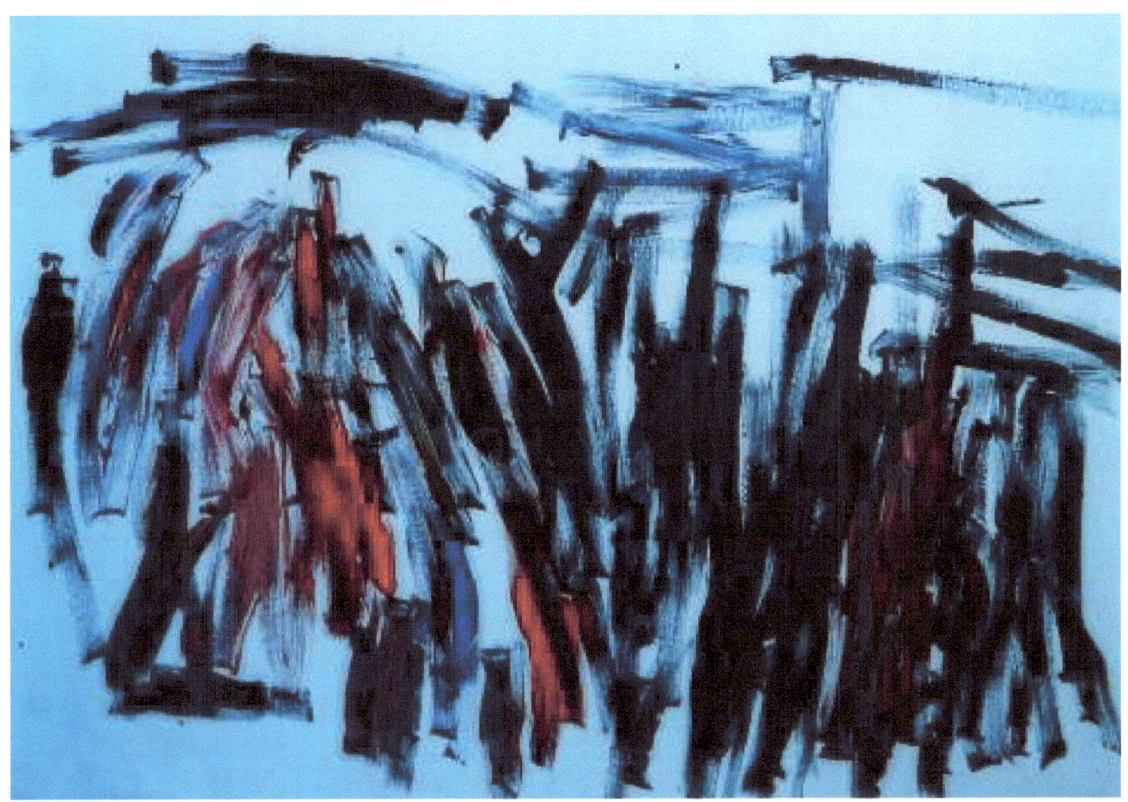

Illusion

You're lives are illusion,
You must decide what is real to you,
Love is rare,
Some say it is as effervescent as steam,
Others its eternal,
For me tobacco and art are real,
A painting is an approximation of the dream/reality you are in.
I will continue painting until I am fooled enough by illusion to die;
Maybe not ever.

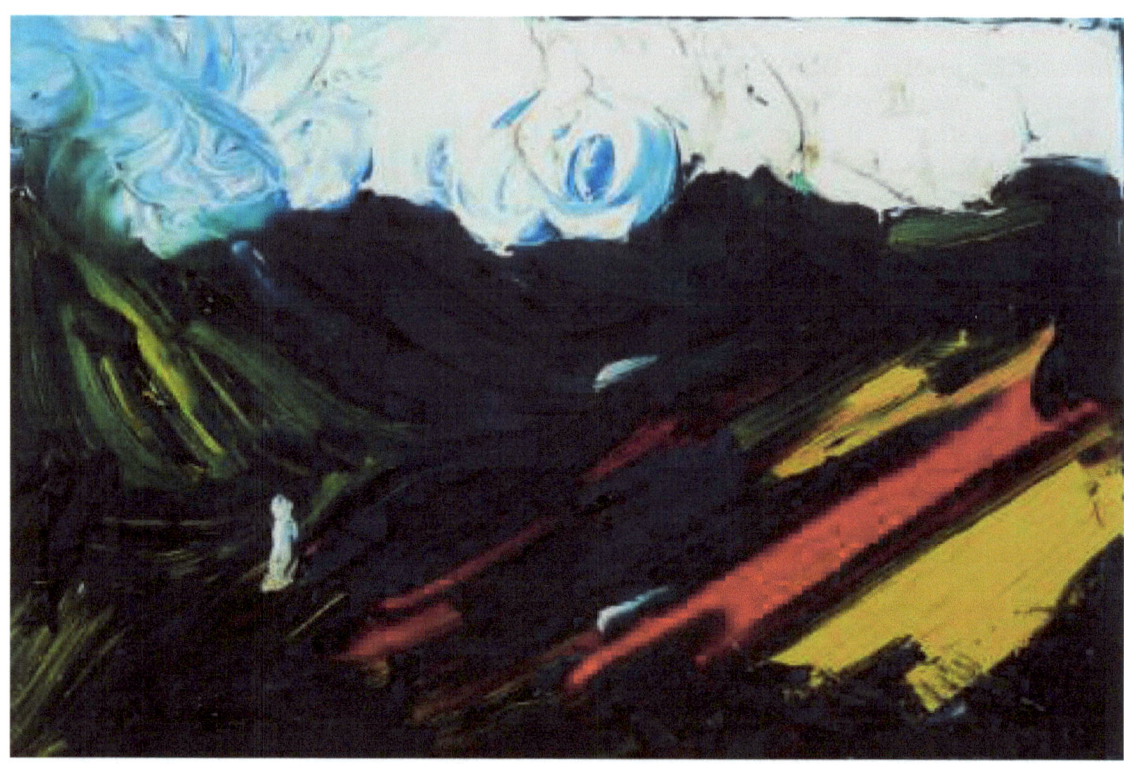

The homeless artist

Penny pincher,
Sleeps on the edge of time,
Dreams of ancient civilisation,
How old is he,
How old is he,
He thought someone in the modern world loved him the other day,
No, she's baiting me,
They'll kill me for sure,
Where are his people,
Where are his people,
Why do they treat him so bad,
The modern ones,
He calls it another damned day,
When he wakes up,
Alone, clothes flecked in paint,
The alcohol isn't strong enough anymore,
How poor,
How poor.

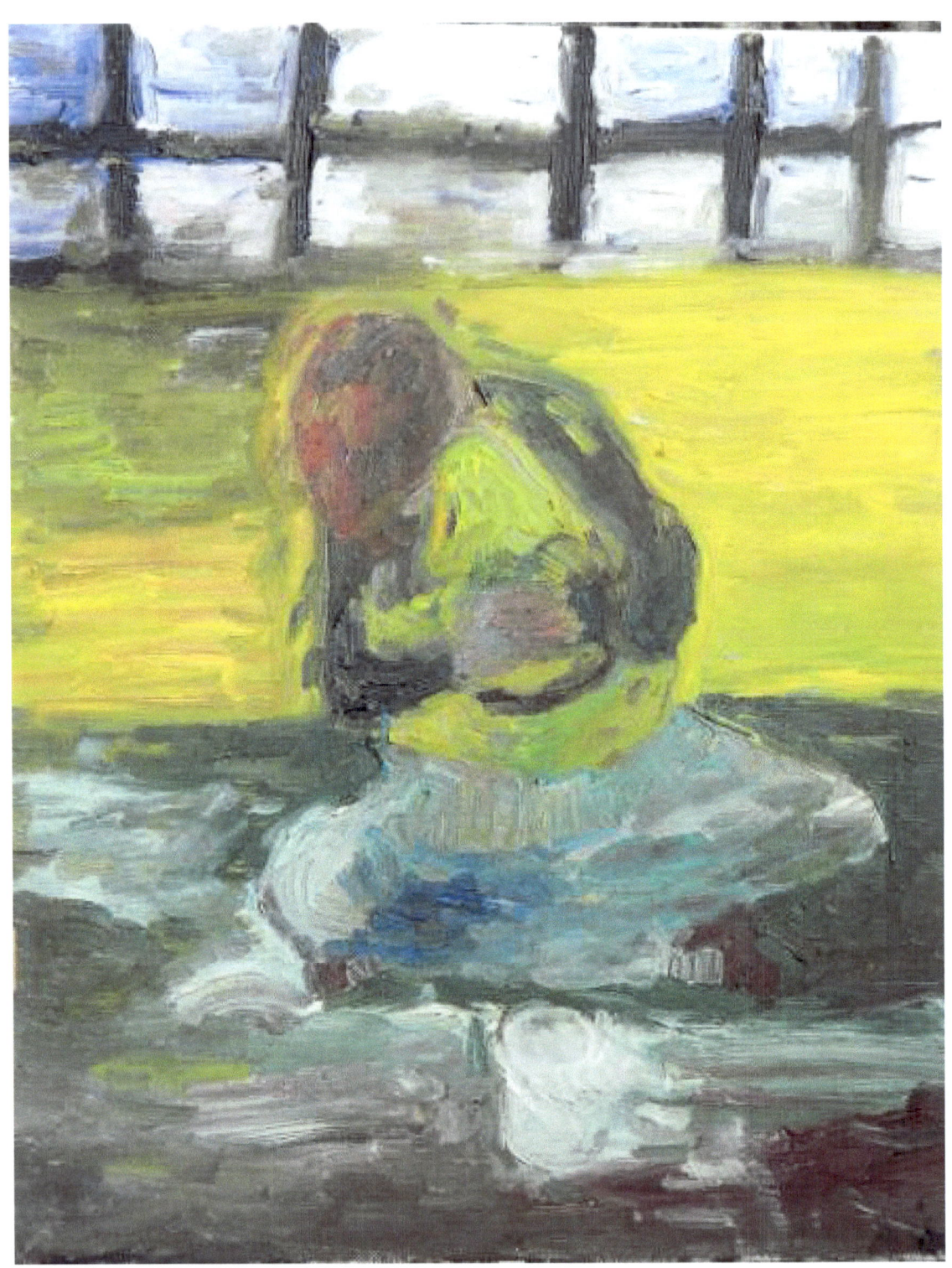

Casablanca

'You did a beautiful thing Boss,
To f*** up a perfect future all over again over a woman,
He met himself coming back and he said to himself,
'It is pointless without love,'
'Round up the usual suspects,
This very same thing happened to me last year.
'This could be the beginning of a beautiful friendship,'
Scream the Gods.

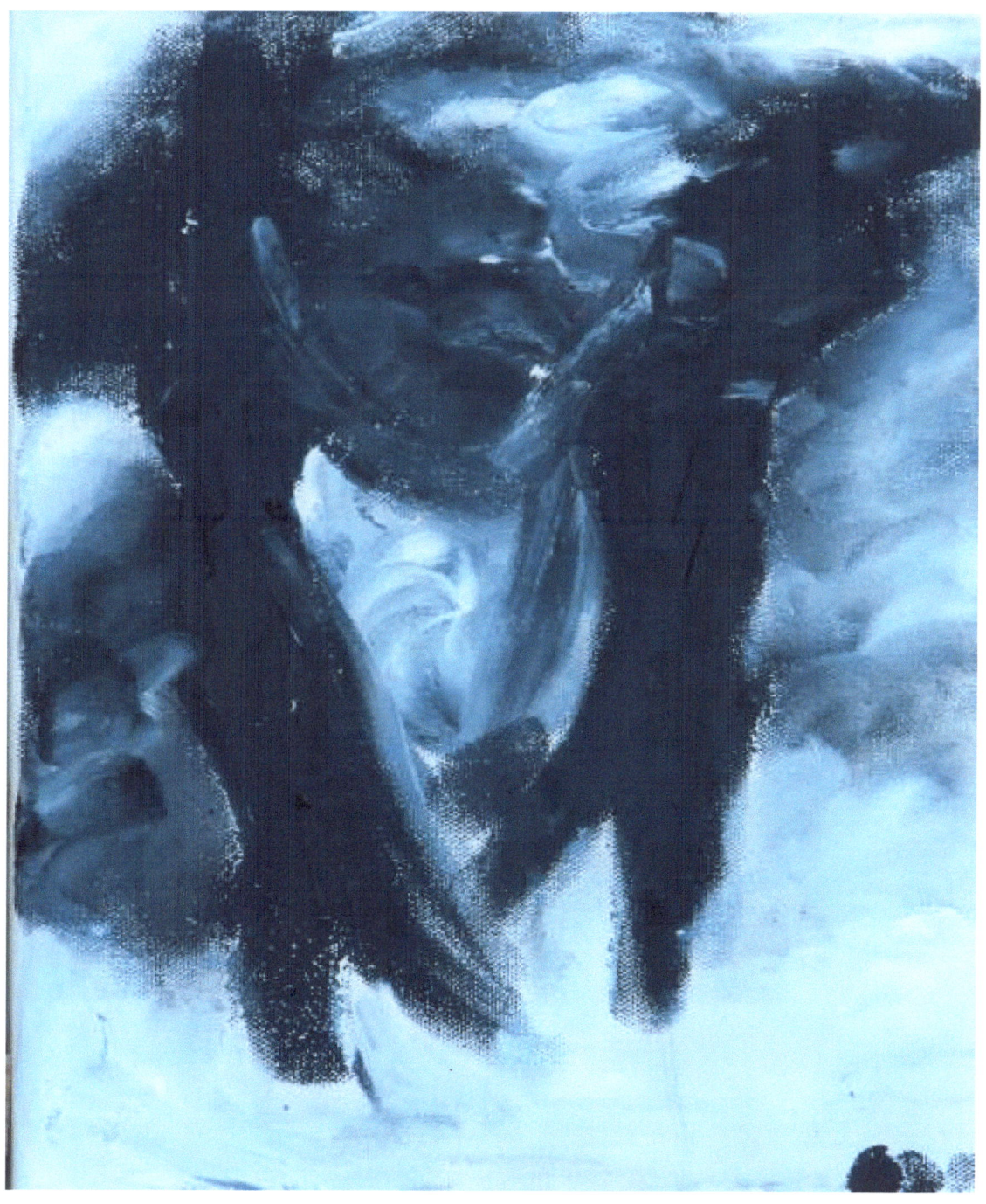

Misery

Oh here comes misery again,
My constant companion,
She says 'I'm a bitch,'
She follows me around wherever I go
Misery loves company,
She keeps asking me why do I love you so much,
And no-one else,
I said,' is it because I'm stinking rich?'

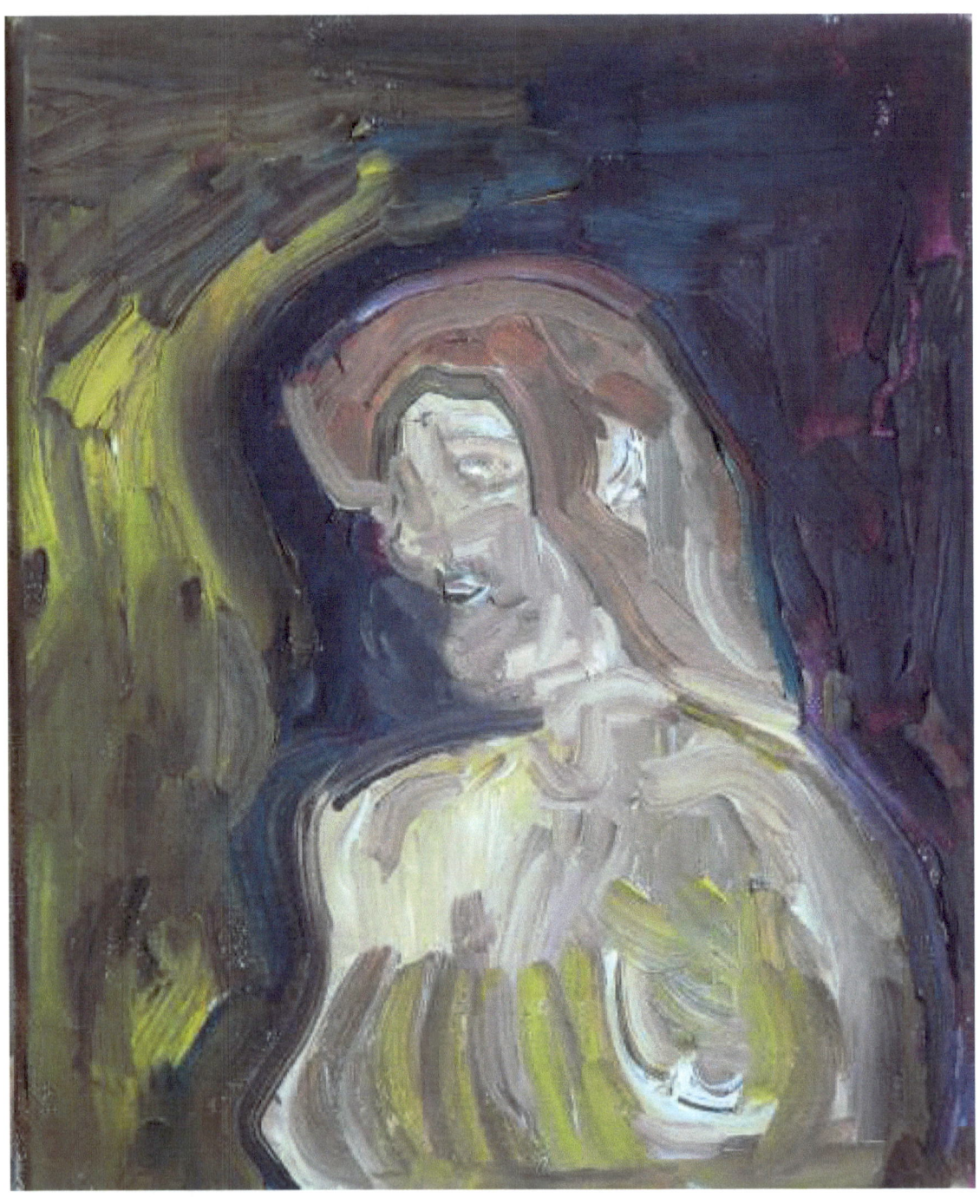

A conservation

'I've had enough of infernal creation,'
'God, how long have you been here?'
'An eternity,' came the reply.

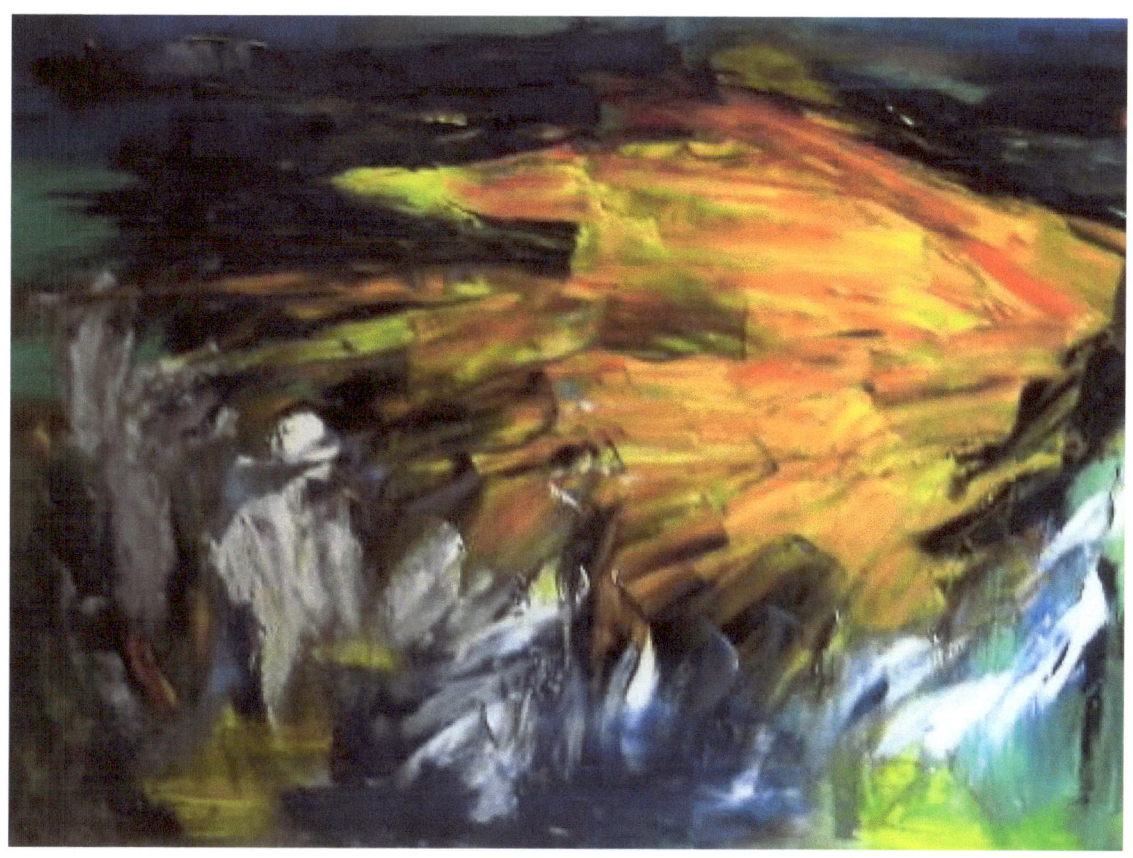

Declining years

As I walk, the countryside seems grey,
The stars revolting in their arrogance,
And I cannot find hope or inspiration,
In even a tiny flower,
Without a drop of mead.

A man

A man is never happy until he truly dies,
Only in a man's dreams is he free,
A man without a woman is tethered by truth,
A man with a woman is comforted by lies.

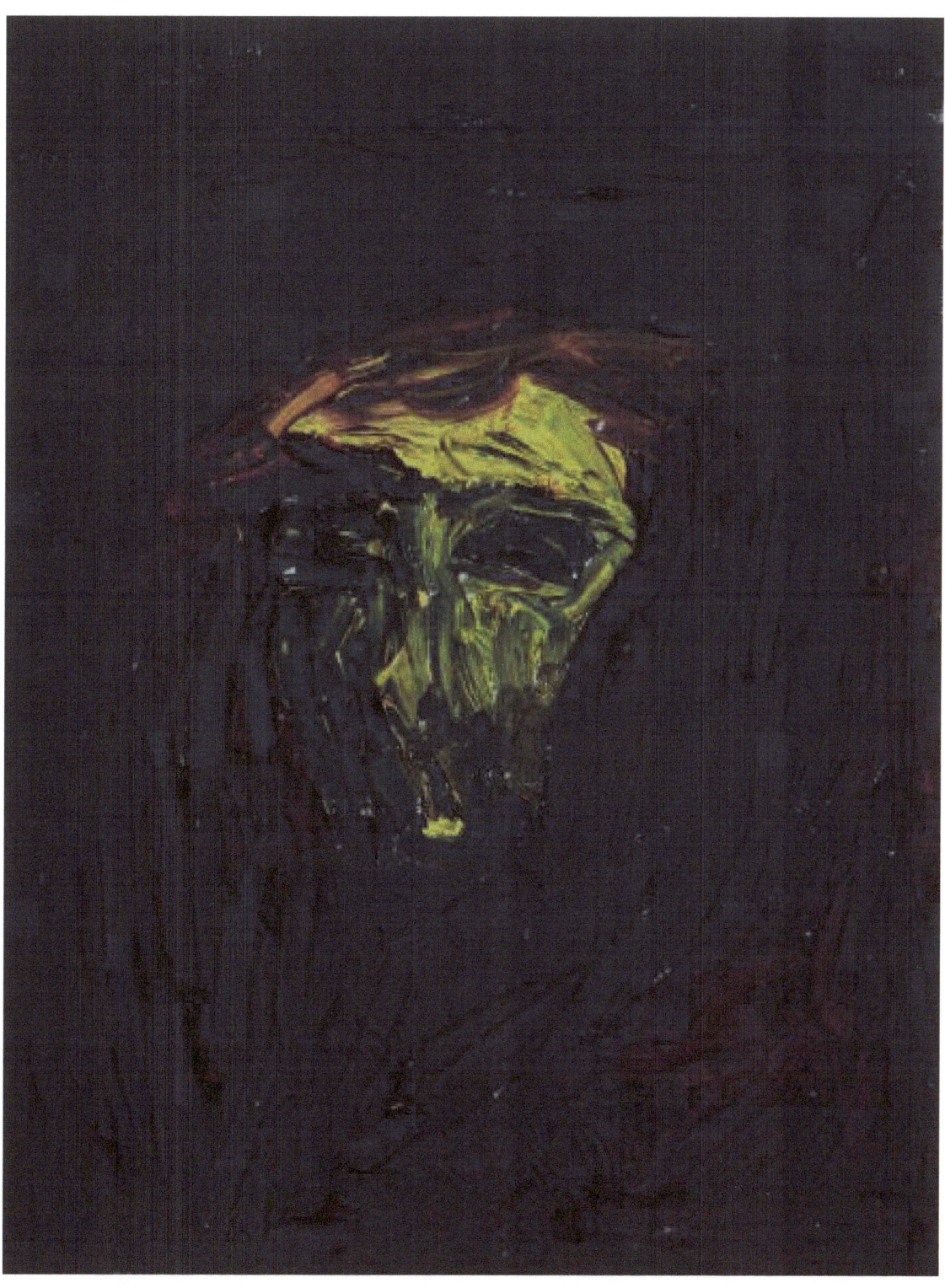

Summer night in November

One star sky,
Roar of waterfall sound,
Father thai birthday,
Cider with Rosie,
Lucy legs,
Quill art sold,
One white goodnight.

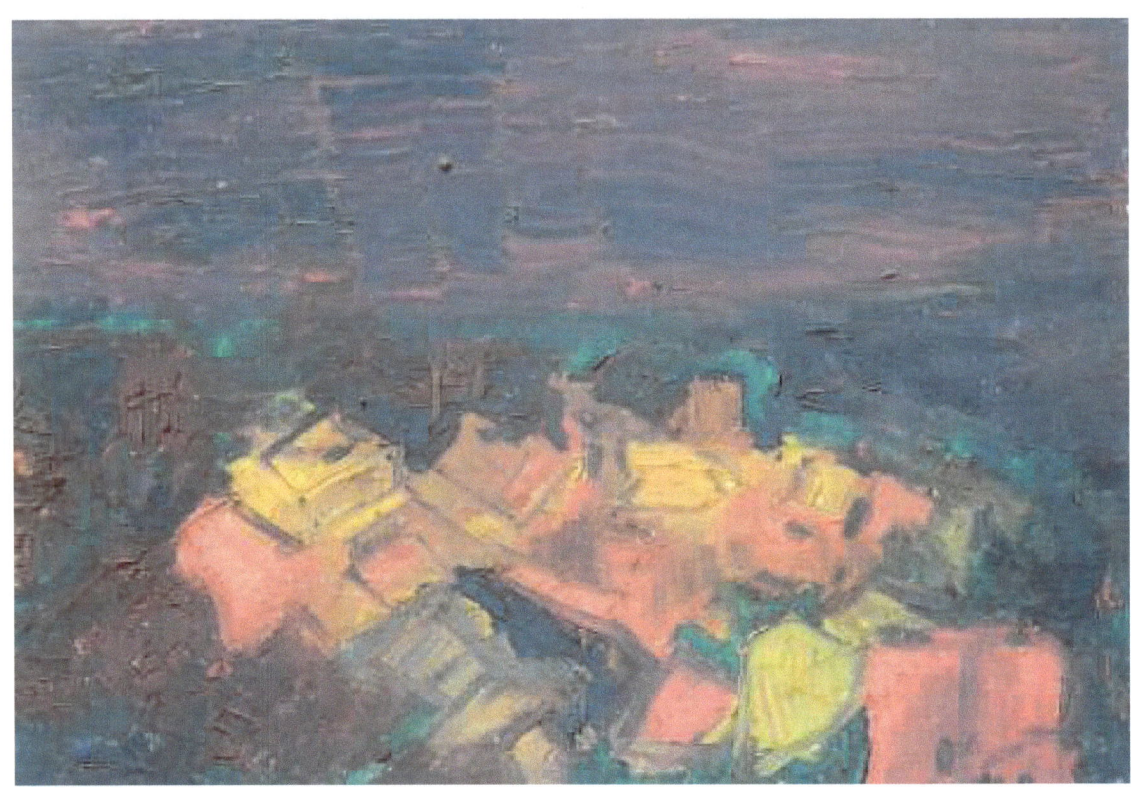

England

The enemy within the world of God,
I've had enough of this conversation,
A smattering,
Daubs the walls.
Money hellbent antiques and plasticine sheep,
No England, Great England,
Whose country houses are so dry,
And art collections not appreciated,
He ships them out to the poor,
Oh English ignorance is a thing of beauty of joy forever,
Not a million toy,
A real piece of art holds meaning beyond tears,
And the better the poor who have none,
Cry a little for what he has done.

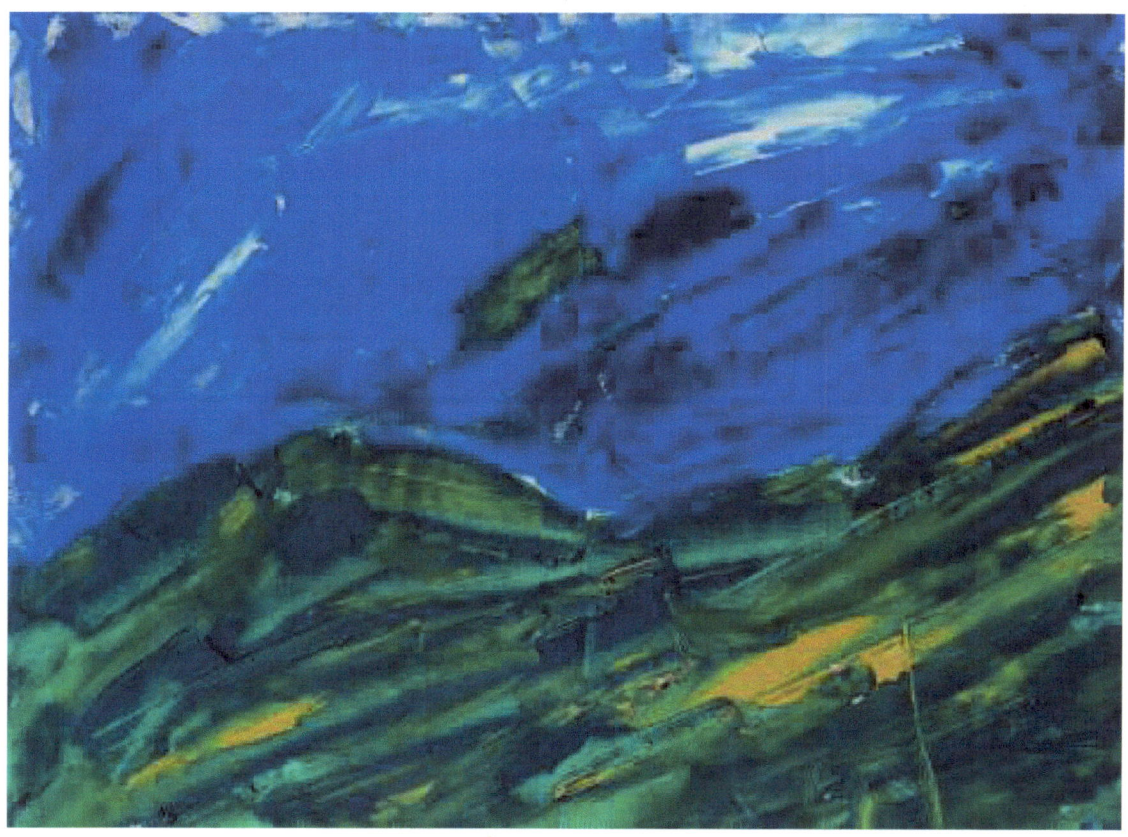

Poem for my daughters

Oh daughters, you set my heart on fire,
When I see you ,think of you,
What eternal power you hide,
What other men will feel I cannot inside,
Fire in my heart this winter,
To warm an ageing poet,
Whilst the snow falls.

A mathematical problem

Future of Pi
+something you don't want to do
X the difference in these loving eyes,
Carry the once and future king of England,
The sum of this is a very rich man.
This years preoccupation is written on the leaves,
That have fallen on the path I walked all year.

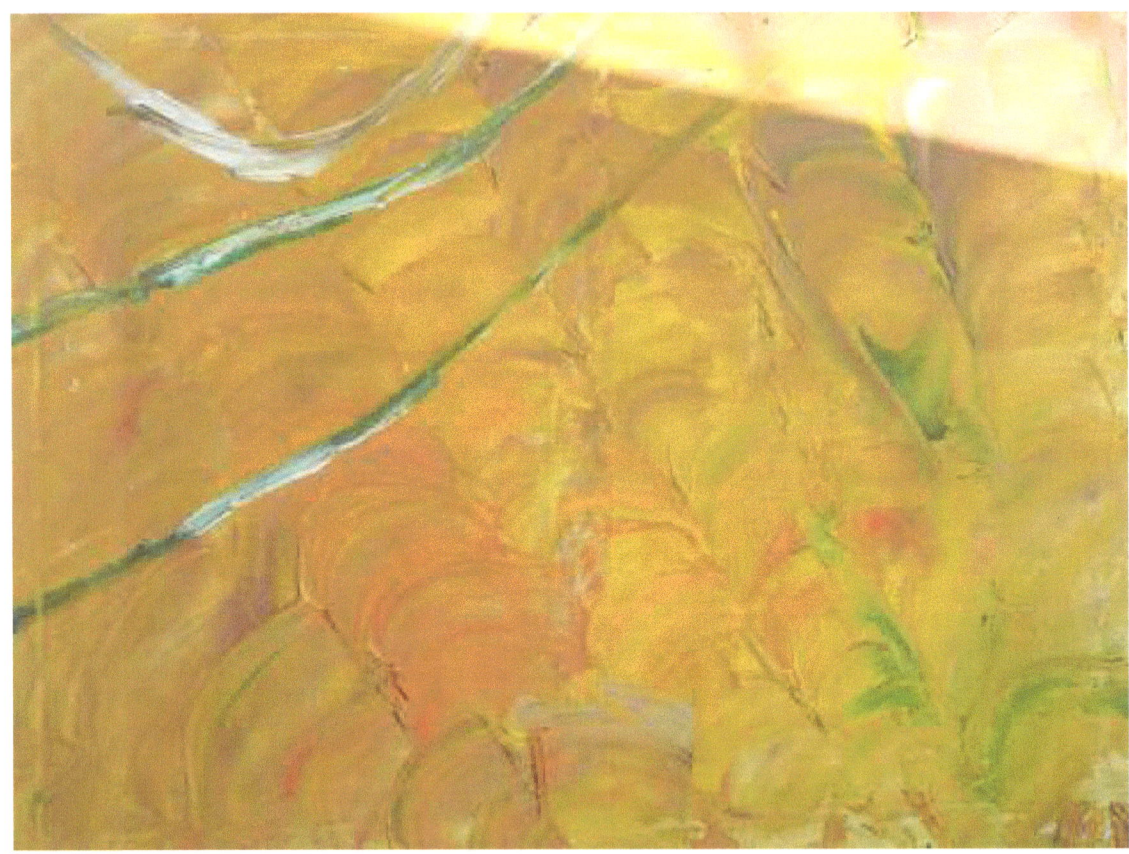

Two points of note

The sun is a machine which broke down last year,
I talked to the dream king who has his work cut out,
And he said ,'who do you think keeps humans hopes alive during the night?'

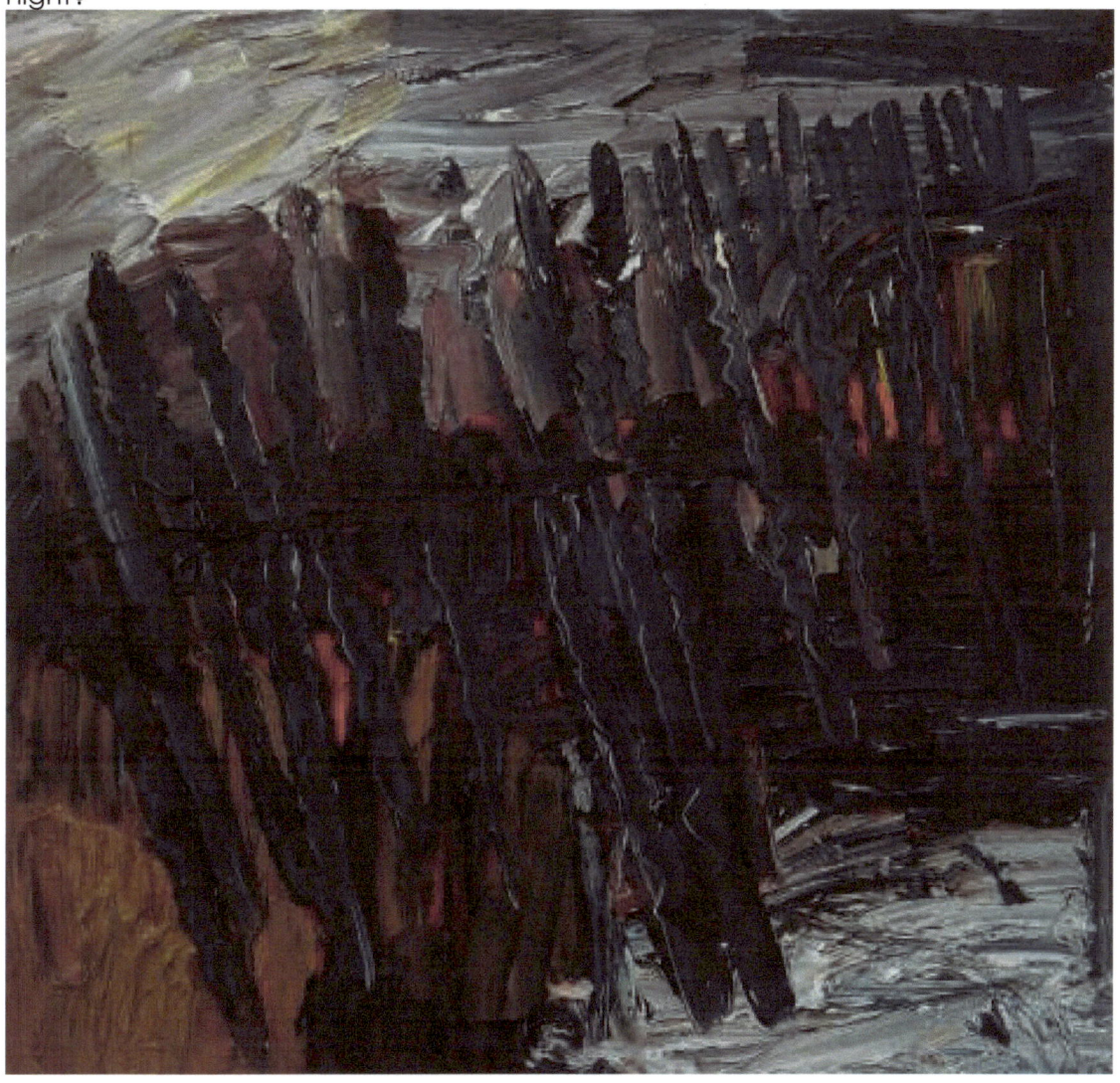

Ghosts

There is a joke going round that the world was destroyed and
We are just
ghosts.

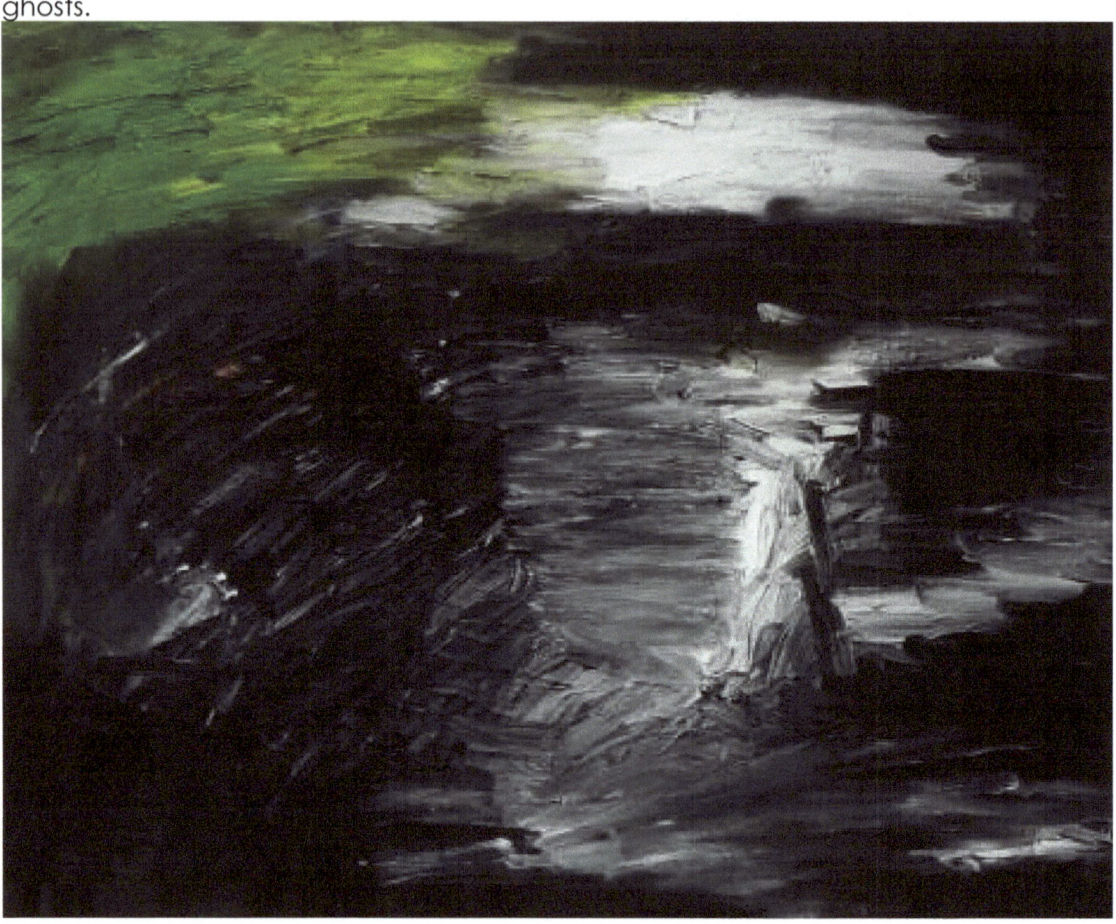

The world's worst invention

Telephones,
These things cause more aggro than any single object in the universe,
Firstly if you ring a service, you're afflicted by a sadist female voice telling you to know your place and follow instructions.
Secondly if you phone someone with a mobile then its practically impossible to reach them because they're high on cocaine.
Thirdly if you try to phone a friend they say 'I'm busy can you can you call back later.'
And fourthly If someone phones you then its probably a company's recorded message saying
'congratulation you've won the east coast of Majorca.'
Finally if you haven't been totally p***** off by now the devil calls you and tells you
'You're going to hell for eternity.'
I've thrown mine out,
Good riddance to bad rubbish.

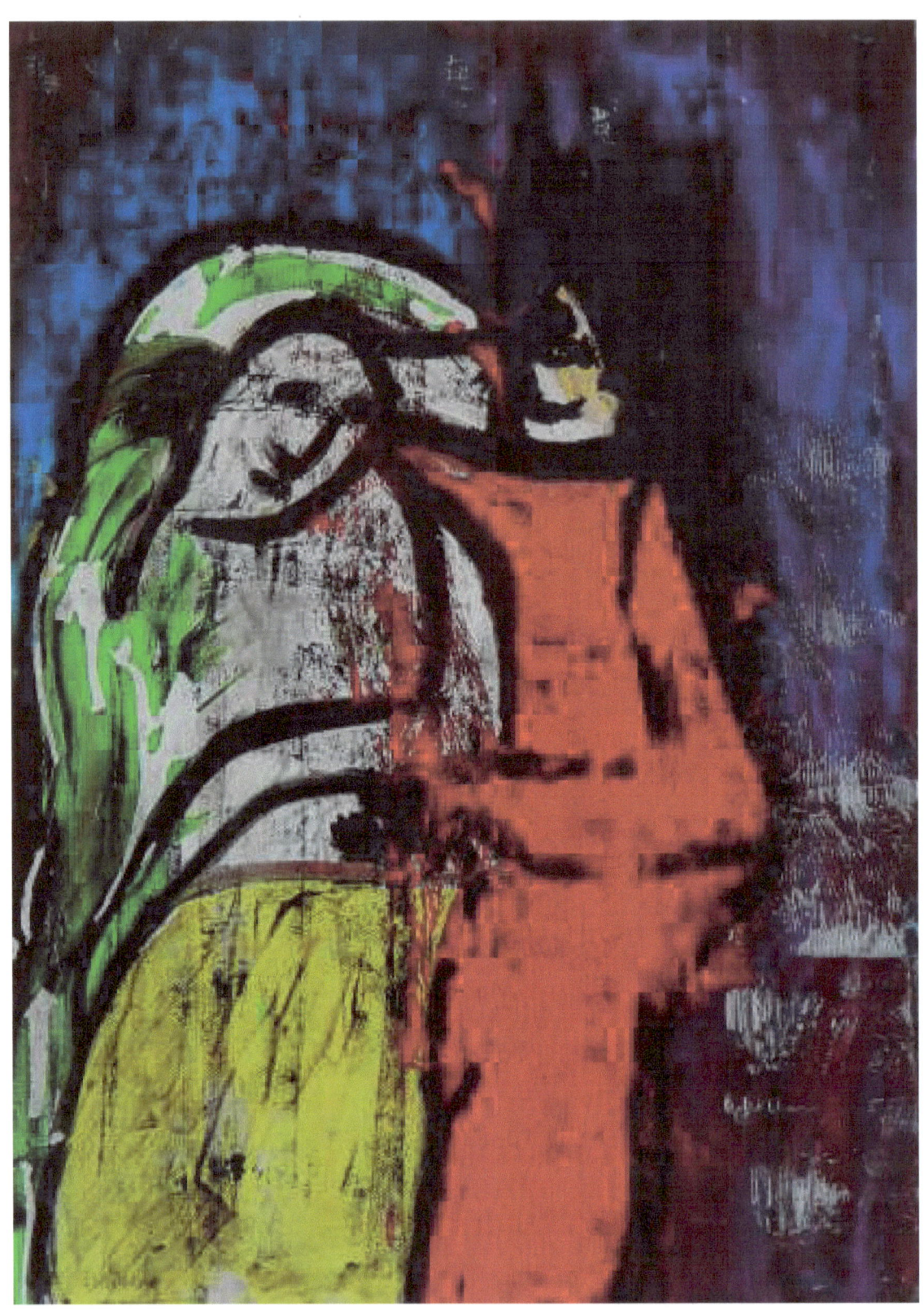

Dream of saving the world

The levels of a certain substance are too low in the sea,
That is why the earth is in disaster mode.

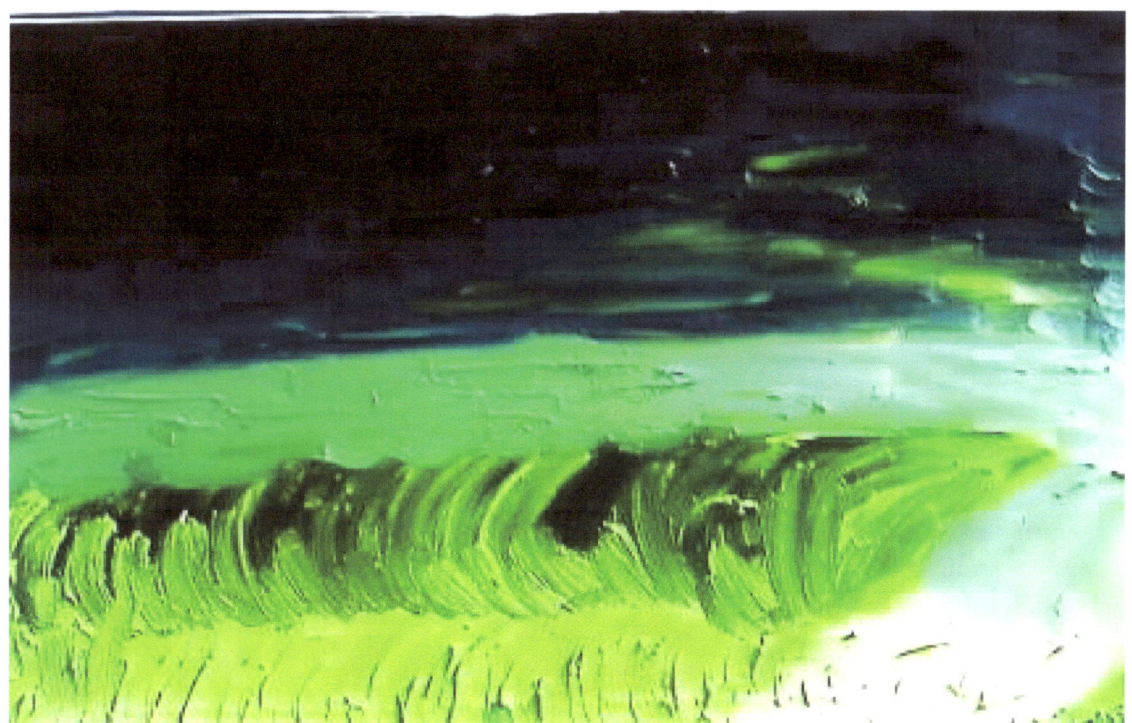

Nervous exhaustion

This is my new fear,
Another new year yes,
But I shake when I wake,
Stutter when called,
And fall and fall.

Too much—it is all.

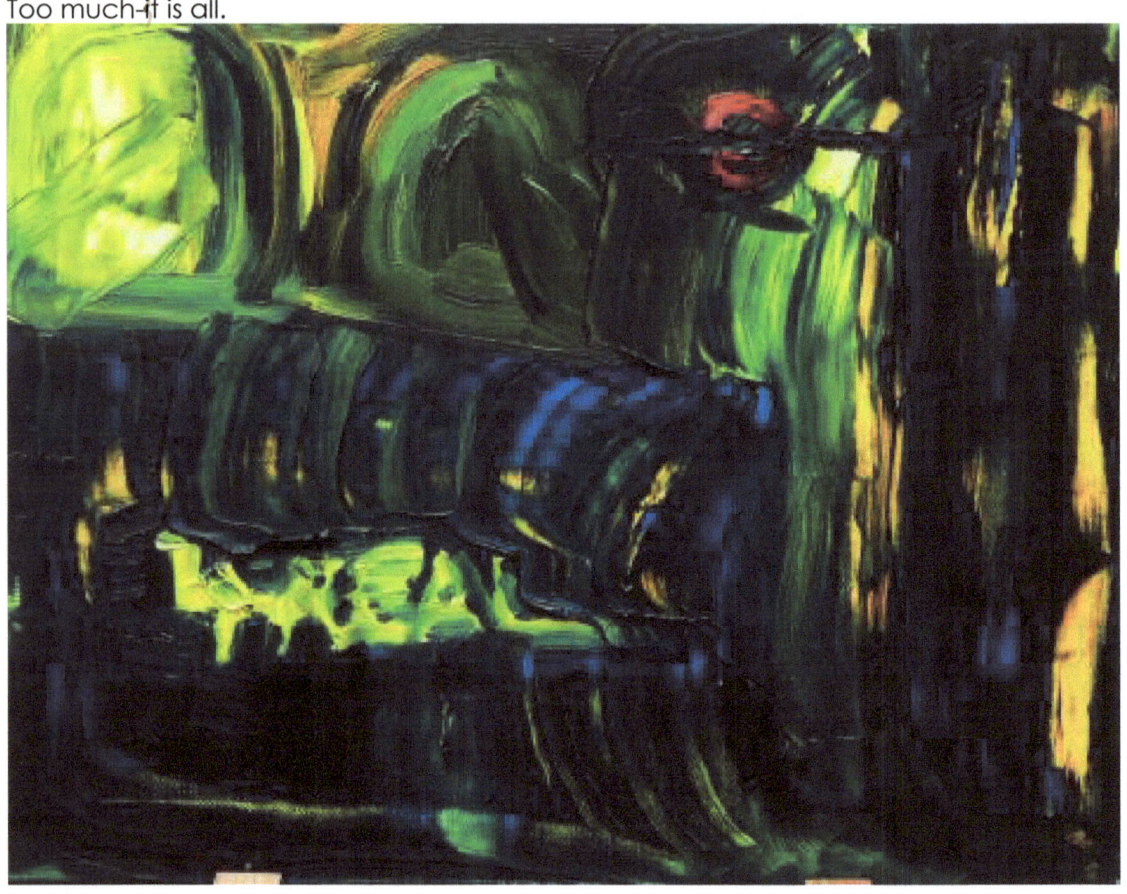

The truth in art

They say paint truth,
Whilst whipping the artsit.
He says the truth is,
Everything but art.
I paint lies,
The truth is disguised;
If only I could see,
One vision of truth,
I would paint it ,
I would promise,
From that day,
To choose a better profession.

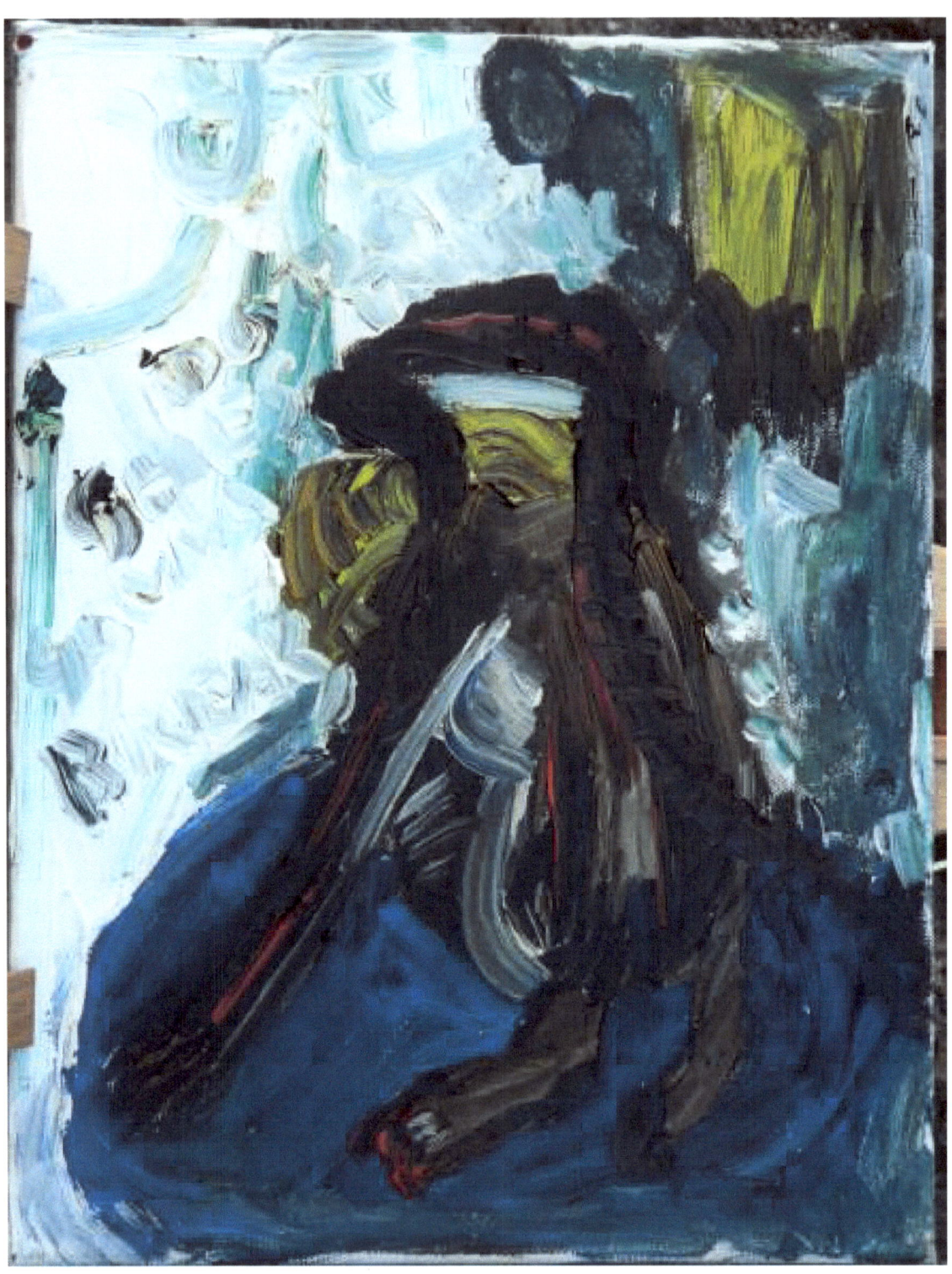

This is my age,
 My wages none,
My life begun,
My hair dreaded,
And a mother's son,
Progeny four,
Score 3-0 down,
Not doing so well,
Been to hell,
Rally against this life of lies,
Seek truth in their eyes,
Oh they all look down,
Truth is we were on the wrong side,
We lost,
I was born on the wrong side of the tracks.

Erudite friends

Noises coming out of the darkness,
You know there is no-one in eternity like you,
Gullible I'm not so I take flattery,
With a deferential attitude to their schemes.

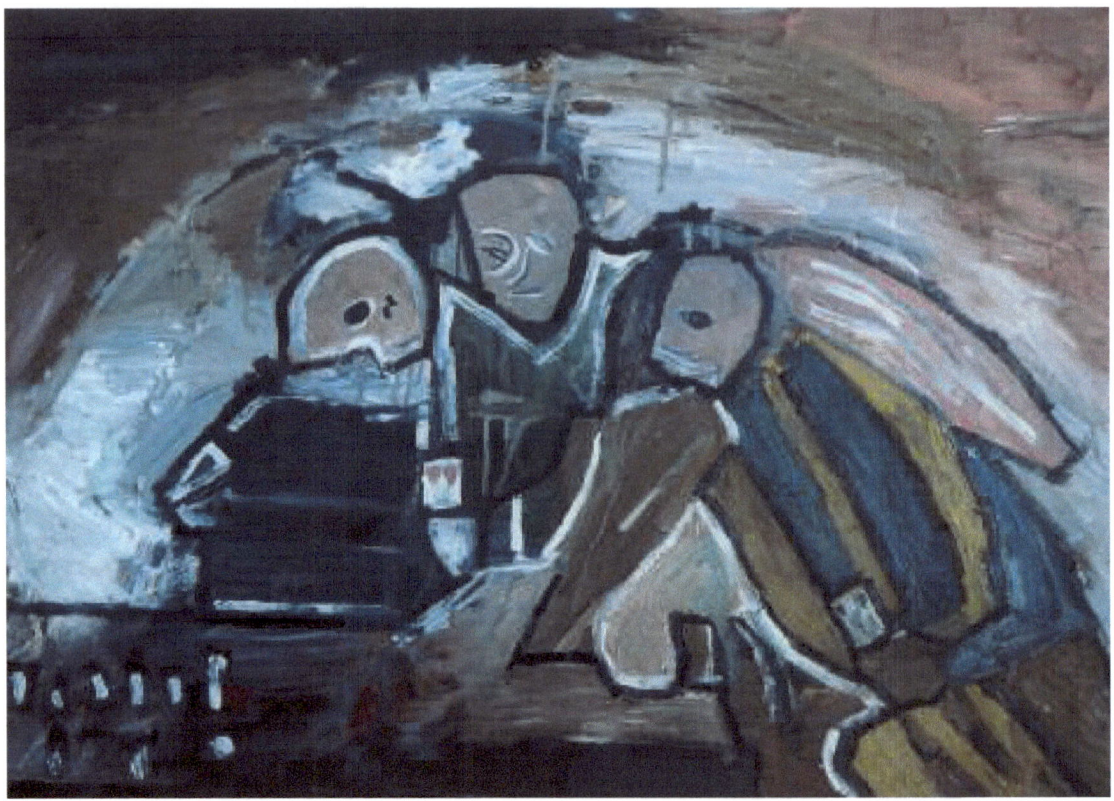

Be still.Still.

The ring

I put it down on the side,
I watched it glow,
I saw whole civilisations rise and fall,
And there it still was,
The ruling ring,
The one thing in the world everyone wants,
Guess what I did with it?
Into the fire,
And then buried.

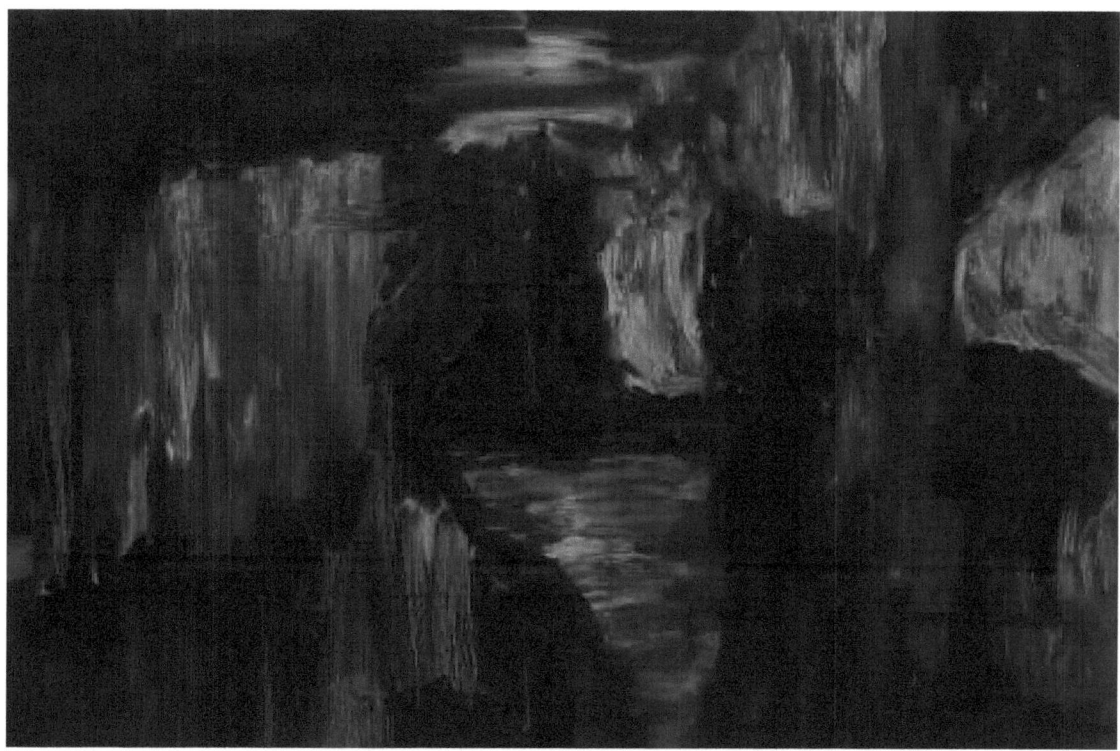

Vincent

Innocent Vincent,
A true friend to me,
5 cent Vincent,
Needed me.
I company him,
Through the night,
Talking over our right,
Still If I ever stray away,
From his word,
Absurd, absurd,
He slurred.

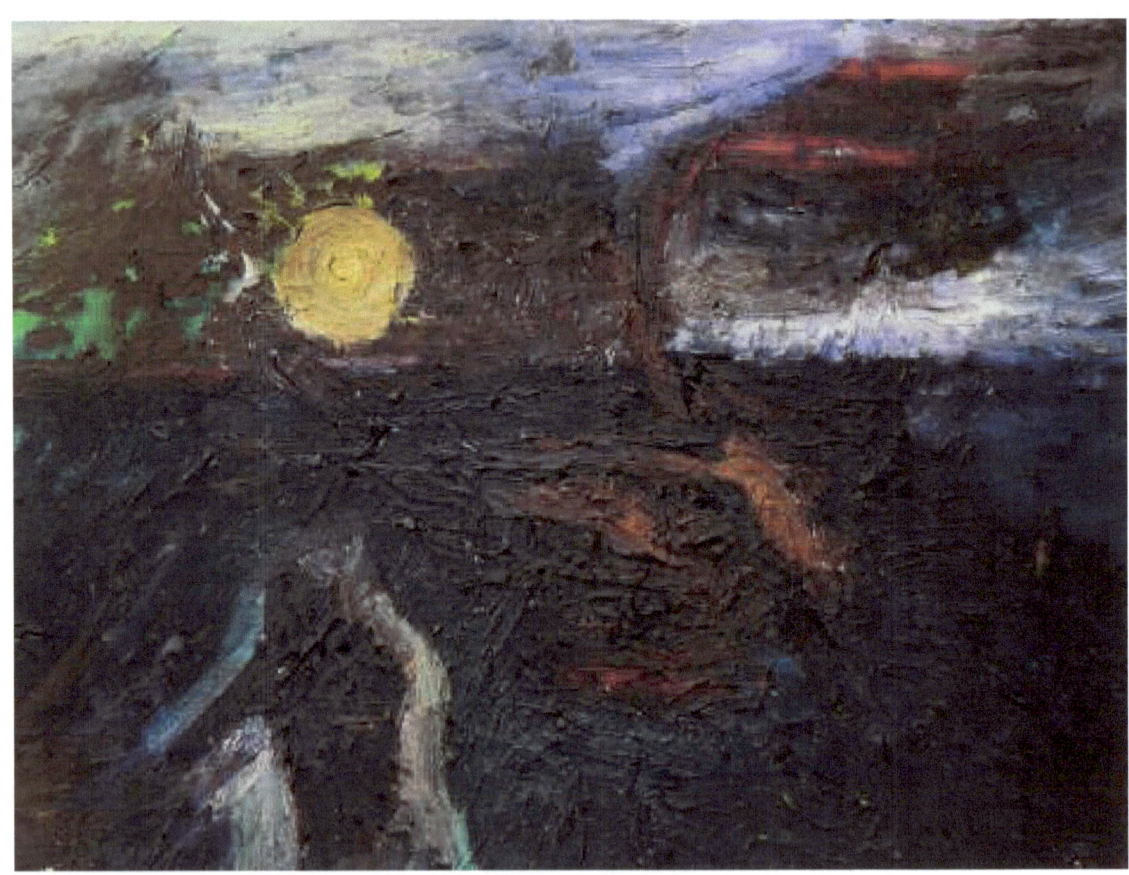

Aids

Don't die of ignorance,
God doesn't exist,
And we really did evolve from monkeys,
And most of us still think monkey thoughts.

OT Department of mental institutions

These are aladdins caves of treasures,
To explore whilst your life is on hold,
The OT manager can help you to create,
Any craft object in the world.
Take it easy in OT,
It's meant to be.

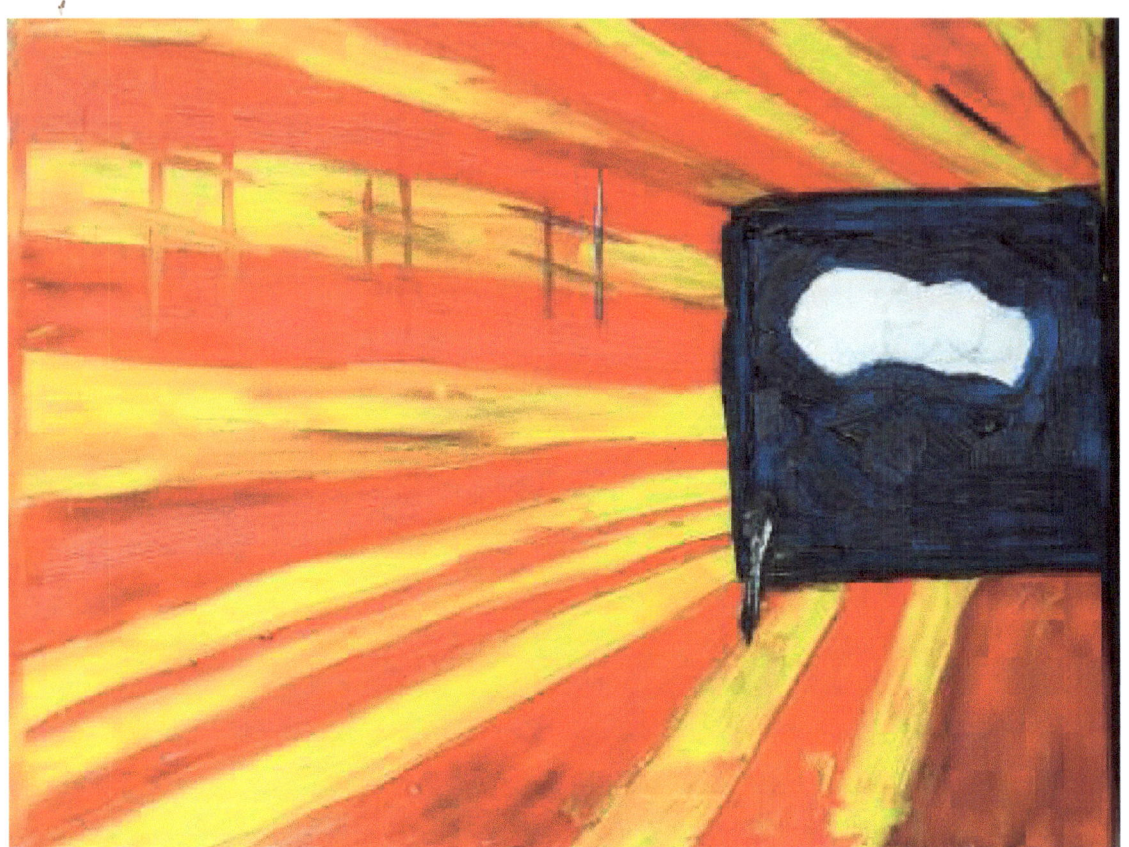

The underground artist

'Every day a painting comes my way,'
This was a person interviewed in Bridport England,
An ARTIST was giving away all his paintings,
On the streets,
And it went on for months,
Now who could that have been,
I begin to wonder?

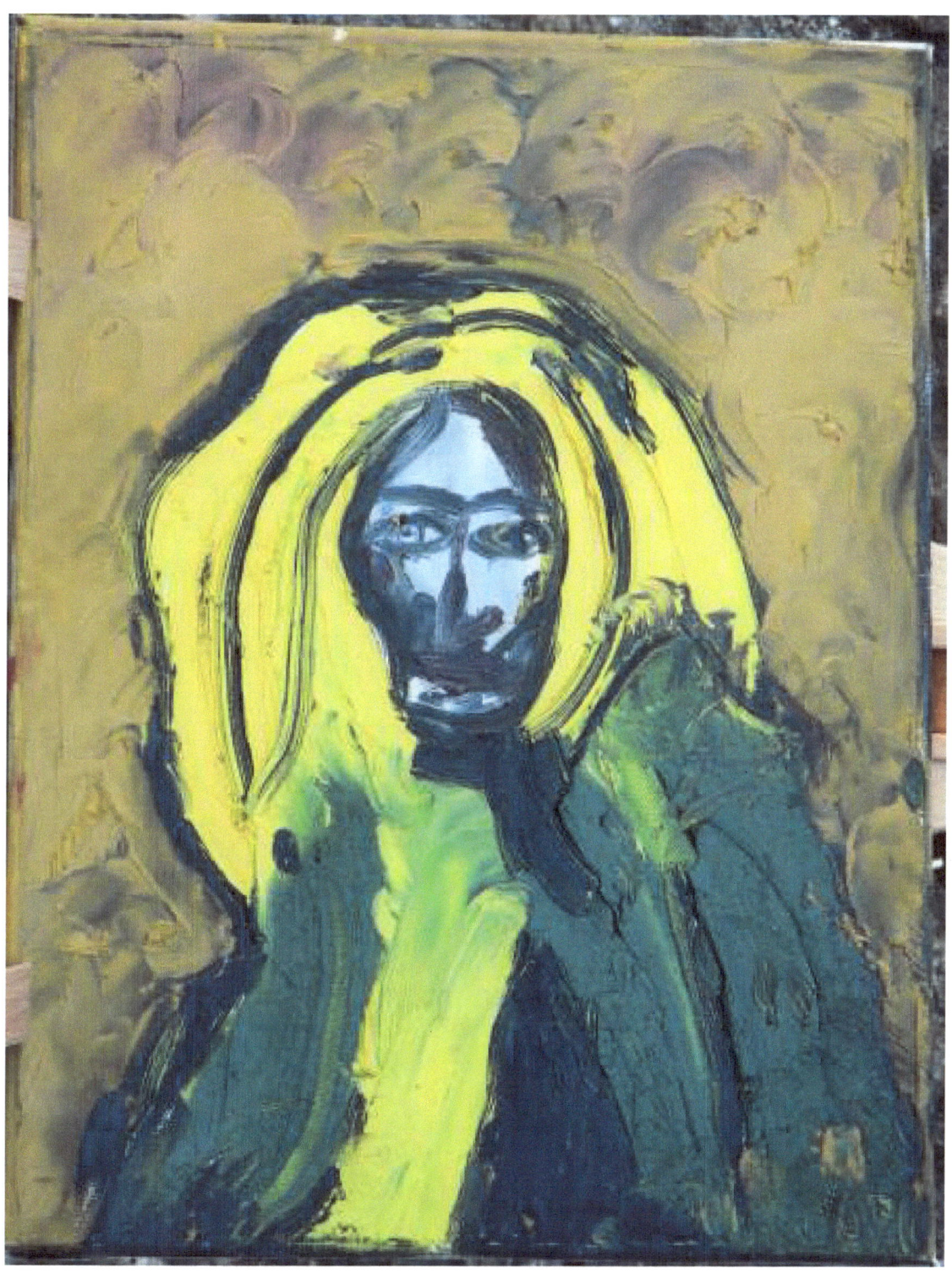

Kirchner

'No-one had his colours,'
He was Germany's redemption,
Paid for it with his life,
Everyone must see his work,
Moves to tears,
Stops the sneers.

A poem for Gilian

'I love to duck'
My fellow conspirator,
In the dark,
Red hair,in despair,
Trusting but in the end above me.

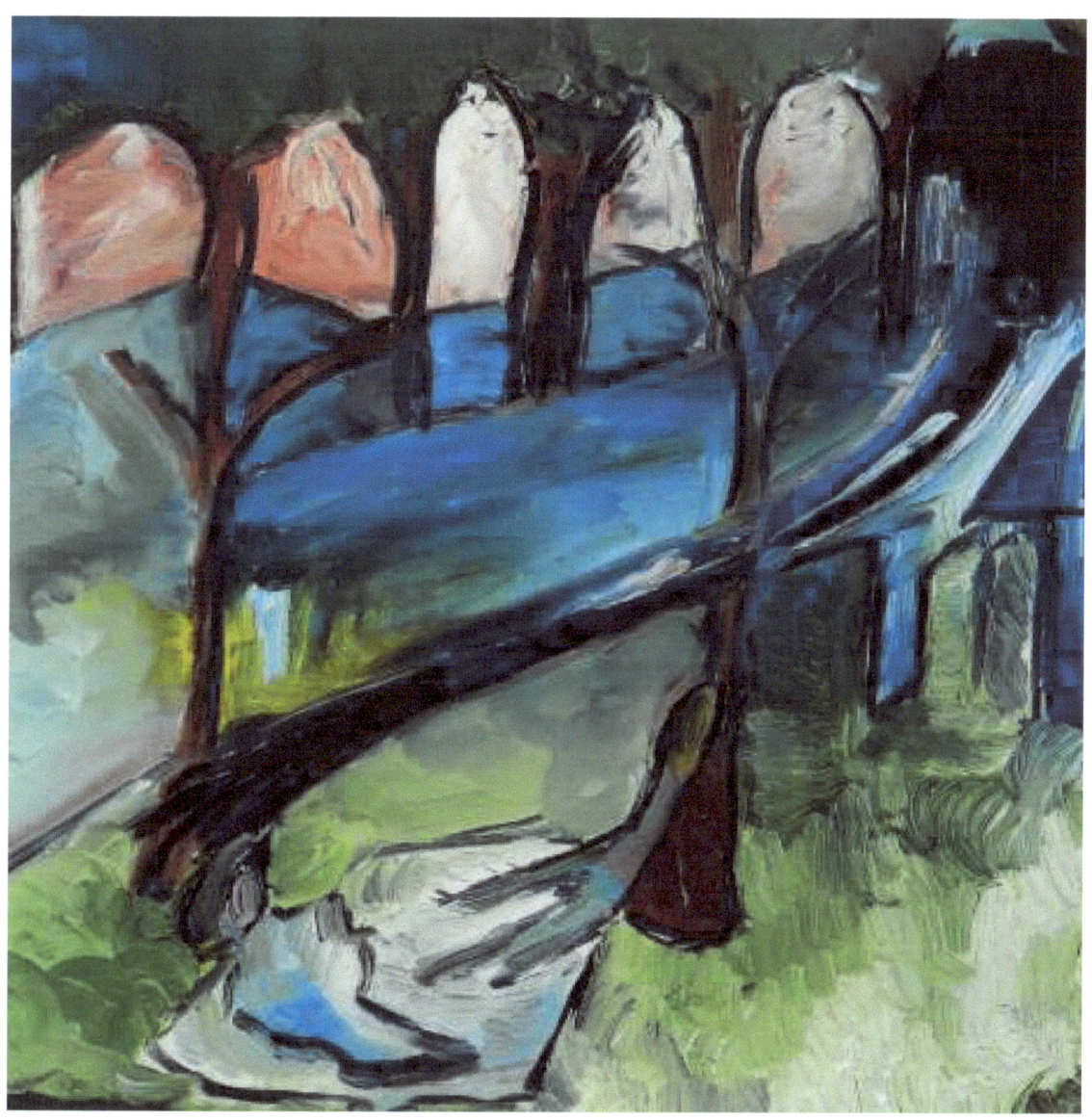

Grandmother

She left us wondering,
Who she really was,
But she said in the end,
'It all seems so unimportant now.'

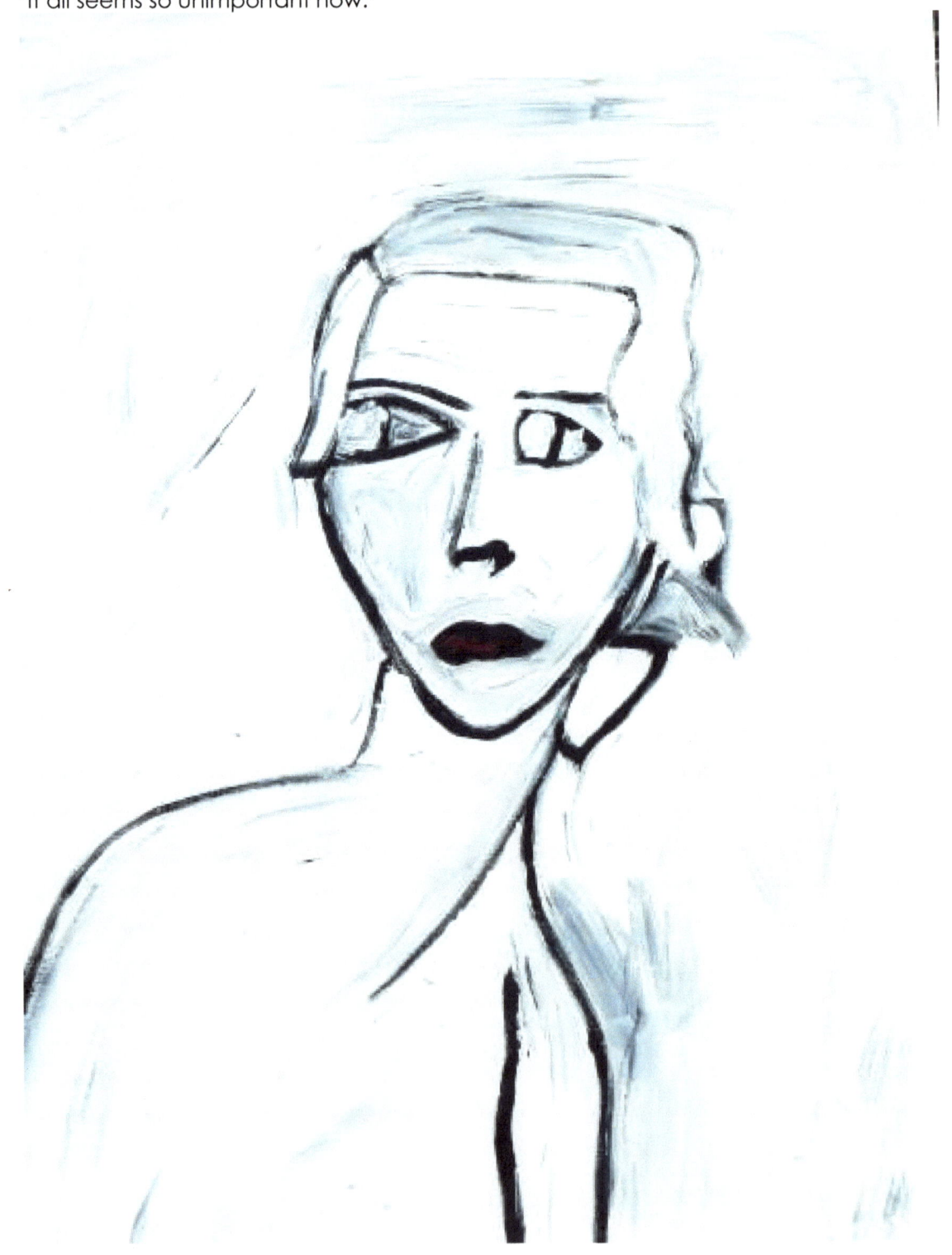

John Constantine

If you need big bad knowledge,
If you are in trouble,
I recommend Hellblazer comics,
Twice daily.

A son

David

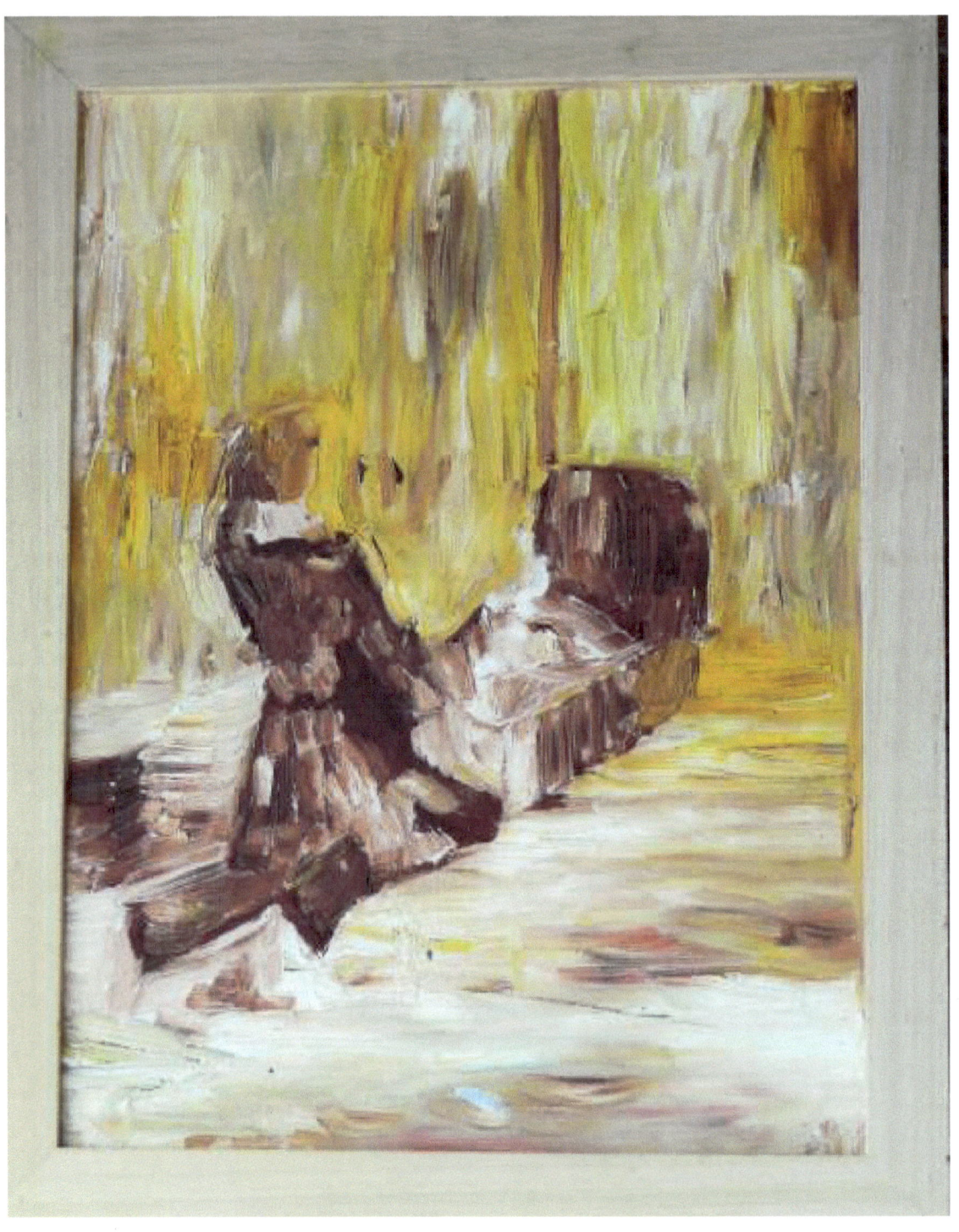

A will

Has been placed in a strong room

A life in writes

Is heading for home.

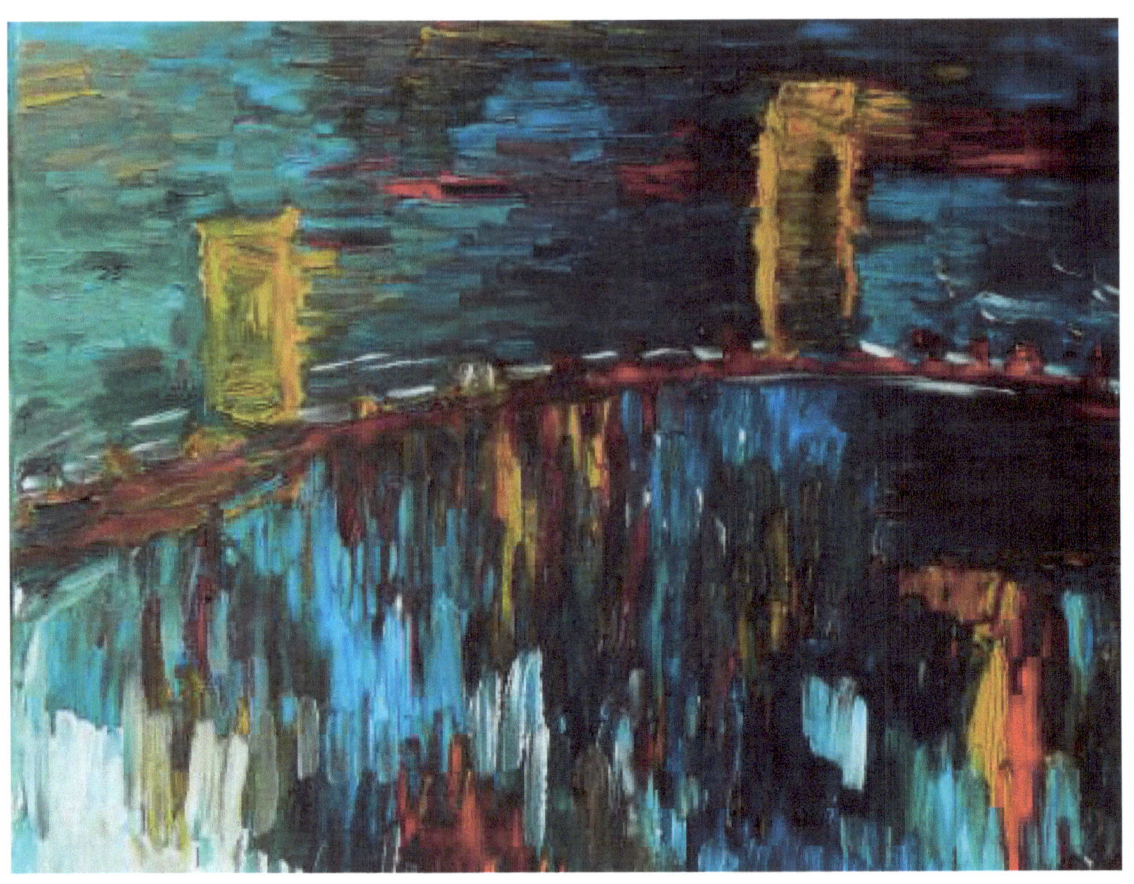

www.ingramcontent.com/pod-product-compliance
Lightning Source LLC
Chambersburg PA
CBHW050814180526
45159CB00004B/1659